Thank you!

[signature]

PORTABLE
ALTAMONT

PORTABLE ALTAMONT

Brian Joseph Davis

Coach House Books

Published with the assistance of the Canada Council for the Arts and
the Ontario Arts Council. We also acknowledge the financial support
of the Government of Ontario through the Ontario Book Publishing
Tax Credit Program and the Government of Canada through the Book
Publishing Industry Development Program (BPDIP).

The author wishes to acknowledge the support of the Ontario Arts
Council through the Writer's Reserve program.

Portions of *Portable Altamont* originally appeared in:
 The Pocket Canon Anonymous Book Series
 (Misprints Editions)
 Number One Fan (Smart Cookie Press)

LIBRARY AND ARCHIVES CANADA CATALOGUING IN PUBLICATION

Davis, Brian Joseph, 1975-
 Portable Altamont / Brian Joseph Davis. — 1st ed.

Poems.
Includes index.
ISBN 1-55245-161-5

 I. Title.

PS8607.A96P67 2005 C811'.6 C2005-903977-9

Freud examined the concept of 'coincidence' in his intriguing and far-ranging paper 'The Uncanny.' Starting with the untranslatable German word *unheimlich* — a word that can mean 'familiar' and 'unfamiliar' at the same time — he surmised that when one experiences a feeling of coincidence, déjà vu or the uncanny, it is an expression of long-suppressed drives and desires.

To wit, if you read this book and draw some strange connections between the name of one of The Author's characters and some famous, legally represented person, you are projecting your own intent onto The Author.

THE PORTABLE ALTAMONT
'FIRST LINE OF THE BOOK' CHALLENGE

The sky above the port was the colour of a video poker screen, broken by an angry drunk.

I saw the best minds of my generation destroyed by Tae-Bo, punching hysterical spandexed, dragging themselves through the renovated streets at dawn looking for a parking spot.

A Chris 'Corky' Burke billboard comes across the sky. It has happened before, but there is nothing to compare it to now.

Last night I dreamt I went to Mandarin Buffet again.

Many years later, as he faced the firing squad, Kid Rock was to remember that distant afternoon when his father took him to discover ice.

Indian summer is like Kenny Rogers. Ripe, hotly passionate, but fickle, he comes and goes as he pleases so that no one is sure whether he will come at all, nor for how long he will stay.

Bryan Adams blows a Skinny Puppy in a Honeymoon Suite, but Randy Bachman and other Asexuals can only be Watchmen.

CANADIAN MUSIC WEEK[1]

Bryan Adams blows a Skinny Puppy in a Honeymoon Suite, but Randy Bachman and other Asexuals can only be Watchmen. Outside, the Sven Gali takes a Cub to Sylvia Tyson for a Sacrifice. A Fifth Column of Platinum Blondes chant 'Surrender Dorothy!' Andrew Cash has a Tea Party with Jane Siberry at the Asylum; they Consume the Dead Brain Cells of Leonard Cohen. Does Connie Hatch Subhumans like Percy Faith and Rik Emmett?

Young Lions fight Glass Tigers using Crowbars and Anvils but puke after too much April Wine — they're DOA. The Doughboys Rush Toronto but are stopped short by Frozen Ghosts. A Triumph for a Trooper is just a Sudden Impact on the Youth Youth Youth. Eric Trips over Shadowy Men and Slashed Puppets while Sarah McLachlan receives Teenage Head from Aldo Nova. Robbie Robertson, the Annihilator, exudes a Rare Air as a Slik Toxik Throb Crashes Vegas with a Razor. Socrates writes a Saga of Conspiracy after too many Choclairs. Anne Murray commits Random Killings and whispers 'Nil ... Neil ... Young' into the Voivod.

Burton is coming.

We have Zero Options.

RUSSELL SMITH

One side of Russell Smith's head is tingling. The other is not.

That's the Pert difference he's feeling.

THE THREE LAWS OF ETHAN HAWKE

Ethan Hawke can be neither created nor destroyed.

The entropy of Ethan Hawke in isolation always increases.

The entropy of Ethan Hawke at absolute zero is zero.

NICK NOLTE

so much depends
upon

a red G
string

glazed with pina
colada

beside the white
powder.

MARGARET ATWOOD

'All that G-Unit shit is garbage compared to the early Atwood joints. Shit, even *Lady Oracle* is better than G-Unit.'

'It's all been downhill since she started hanging out with Suge Knight.'

'What about the B-side where she drops the famous Bob James "Nautilus" break? Dope shit, my friend.'

'Her human beatbox routine is weak.'

'50 Cent fell off after *Guess Who's Back?* I'll never buy him again. I own a dozen Atwood albums, and I'll buy her next one too, even if she still uses those cheesy Death Row synths.'

WHITNEY HOUSTON

Whitney Houston is every woman and it's kind of weird. She gave birth to me in 1975. She was my kindergarten teacher in a corduroy skirt. She broke my heart in the fourth grade but passed me an Oh Henry bar with a love note attached when we were in the seventh grade. Today, Whitney said I didn't have the right paperwork for a health card. I saw sadness in her eyes that echoed far beyond our brief kiosk flirtation.

TONY DANZA[2]

'Really, the work I'm doing on television isn't that diff-
erent from the more conceptual aspects of my oeuvre.
Taxi is a collision site of temporalities, the dispatch stand
an ever-mutable polyglot node of streaming discourses
and indeterminacy. *Who's the Boss?*, I think, provided less
liminal space for the audience to parse their own mean-
ings, but I'm still proud of it — a Buñuelian black comedy
of manners, a serious negotiation of destabilized, abject
masculinity.'

NANCY McKEON[3]

Nancy McKeon, more beautiful than an airplane, is sitting on the monkey bars, holding the cup of life.

'Hey,' she says to me, 'want some?'

Blair is going to be *so* jealous.

THE HOLLOW MEN
a dramatic reading by the Swedish Chef

Leefe-a is fery lung

Betveee zee desure-a
Und zee spesm
Betveee zee putency
Und zee ixeestence-a
Betveee zee issence-a
Und zee dee-cent
Fells zee Shedoo
Fur Theene-a is zee Keengdum

Thees is zee vey zee vurld inds
Thees is zee vey zee vurld inds
Thees is zee vey zee vurld inds
Nut veet a bung boot a vheemper

Hurty flurty schnipp schnipp!

ALLY SHEEDY

Dear Michael Edwards,

I very much want to apologize for the events that occurred late in the evening of March 11, 1994. You were on purple microdot and I took advantage of your altered state by reading aloud from Ally Sheedy's collection of poetry, *Yesterday I Saw the Sun*.

I apologize for claiming that these poems were the last known writings of Friedrich Nietzsche. My only excuse is that I was eighteen and I can only hope you've gotten on with your life.

JODIE FOSTER[4]

Lee Harvey Oswald shot JFK to impress Jodie Foster. She was only two but she already held great power and influence over angry loners and aspiring poets.

KIEFER SUTHERLAND

Kiefer Kiefer bo Biefer
Bonana fanna fo Fiefer
Fe fi fo Miefer

Kiefer!

BRAD RENFRO

'Where am I?' he asks.

'You're in the land of the dead,' replies Cameron Diaz, stepping from the shadows.

PHILIP ROTH

I never should have trusted you
when you told me that you were
David Lee Roth's brother.

DARREN WERSHLER-HENRY[5]

At his last parole hearing on April 21, 1992, Darren Wershler-Henry, the defiant ampersand still visible on his forehead, responded to the accusation that he, along with Christian 'Tex' Bök, had ordered the murders, telling the three-man parole board that 'Everyone says that I was the leader of those people but I was actually the follower of the children ... I didn't break God's law and I didn't break Man's law.'

As with each of his prior appearances, he did virtually all the talking. The most routine of questions would launch him into unstoppable stream-of-consciousness lectures that contained references to God, the economy, Rambo, the Queen of England, the Crimean and Boer Wars, the Pope, J. Edgar Hoover, hobos, Vietnam, chess, General MacArthur, Harry Truman, ninjas, the San Diego Zoo, Mandy Pantinkin, gangster Frank Costello and a myriad of other people and subjects including the relationship between does and bucks and dogs and chickens.

VAL KILMER

has not moved for days

stinking and unshaven
he stares
at the glass on the table
trying
to move it
telekinetically
to his lips

SEAN PENN

Sean Penn doesn't cry anymore.

I, HILLEVI ROMBIN

With a bloodstained tiara, Sweden's Hillevi Rombin ruled as Miss Universe during 1955. All classical accounts of Rombin agree that she possessed elements of madness, cruelty, viciousness, extravagance and megalomania, and was a coarse and cruel despot with a fierce energy and an extraordinary passion for sadism. Judges noted that she was tall and elegant, gifted with poise and perfect elocution. The first months of Rombin's reign were mild and her policies showed some sound political judgment but even then she took much pleasure in attending punishments and executions, preferring to have them prolonged. In a few months she entirely exhausted the treasury and it became a capital crime not to bequeath everything to Miss Universe. People suspected of disloyalty were executed or driven to suicide. Pearls were dissolved in vinegar, which she then drank, and she liked to roll on heaps of gold. She suffered from severe insomnia, never sleeping for more than three hours a night, but even then did not rest quietly.

HOW THINGS WORK:
AXL ROSE'S HAIRPLUGS

Axl's surgeon will use a special tube-like instrument made of sharp carbon steel for punching the round graft out of the donor site.

The donor site holes will then be closed with stitches. To maintain healthy circulation in the scalp, the grafts are placed about one eighth of an inch (three millimetres) apart. In later sessions, the spaces between the plugs will be filled in with additional grafts. They will come together fine.

All we need is just a little patience.

REESE WITHERSPOON

Our first apartment together, the dead cold of morning.
Reese is sitting at our thrift-store kitchen table, her smile
a knife in a capitalist's back.

'Fuck our Marxist reading groups, our impotent petitions,'
she says with candy-apple nonchalance. 'Life is meaningless
without direct action.'

Mixing her Lancôme with one part gasoline and one part
L'Oréal lip gloss, she makes napalm.

'Nabalm,' she laughs.

On the futon, a dog-eared Noam Chomsky book stained
with our love. The sweet gasoline smell on our bodies for
days.

FIST FULL OF DOLOR

Mary Hart and I, we know the inexorable sadness of
 tanning salons
Neat in our boxes, dolor of models the weight of paper
All the misery of Ricky Martin and mucilage
And I have seen dandruff from the heads of personal
 trainers
Finer than flour, alive, more dangerous than protein
 powder
Sift, almost invisible, through long aerobics of tedium
Dropping a fine film on scrunchies and delicate leotards
Glazing the hair implants, the duplicate orange standard
 faces

JIMMY STEWART[6]

Jimmy Stewart is walking down the street towards me, all weird blue eyes and fedora. He's standing right in front of me. Jimmy Stewart, but he looks funny. He growls this low mad growl, grabs my balls and sniffs around. So I stand still, really scared, and he sniffs around. He gets scent of something else in the wind, lets go of my balls and bolts off down the street. Still growling.

PATRICK SWAYZE

Dirty and cheap, like a discount lingerie shop. That's how my head feels, he writes, just before he turns off the lights. He kisses his sleeping wife's forehead, leaves his Malibu home at three AM. Down to Kinko's on Sepulveda to make thirty copies of the latest issue of his personal zine, *Cataclysm Boy*. The cover is a collage of astronomical charts and pictures of tornadoes clipped from *Time* magazine. The logo is hand-drawn magic marker, but he likes its simplicity. He recently traded ads with Ewan McGregor's anarcho-zine, *Sheep Fucker*, in an effort to boost sales.

Later, when he is sure no one is watching, he glues sparkles and stamps smiling kitties on the front cover.

Each one slightly different.

BJÖRK[7]

A phone call from her is bad. To the point where you hold the phone away from your ear. For hours on end, Björk recalls the pedestrian details of her day without inflection or embellishment. 'I went to work ... and my feet hurt ... and Larry was talking to ... the bald guy from marketing ... yeah, with the nose ... I had a salad ... not a good one ... but an okay salad ... '

Ending up at her house is even worse. She only has two CDs (The Corrs and *The Very Best of the Eagles*) and no CD player. She'll turn the TV on and there's nothing left to do but read Don Henley's liner notes.

PHIL COLLINS[8]

The wraith of Tupac Shakur followed me for three days, carrying with him three tattered plastic shopping bags filled with objects. Reaching in the bags, I find:

> a cabbage
> spent fireworks
> a copy of *The Late Great Planet Earth* by Hal Lindsey
> a Phil Collins cassette (*Face Value*) with no cover
> the Spear of Destiny
> partially chewed bread
> my first pair of Velcro sneakers

My mother had given Tupac my beloved Wildcat Velcro sneakers. I had always wondered where those went.

HILARY SWANK

The sun sets in Hilary Swank's mouth.
Careful, Hilary — you don't know where it's been.

JENNIFER LOPEZ'S 35TH BIRTHDAY

_____, the infamous Hollywood prankster,
(rising male TV star)

presented shocked guests with blown-up stills from

_____'s _____ exam. _____
(someone from Ocean's 11) _(invasive, painful procedure)_ _(E! journalist)_

overheard _____ pitching _____ to
(respected British actor) _(member of fading boy band)_

star in their dream project, _The Moped Diaries_, a bio-pic

about a youthful _____, his love
(us-appointed despot with mysterious skin condition)

life and his growing awareness that, one day, he must

oppress the people.

_____ was screaming, 'I once snorted coke off
(from Who's The Boss?)

_____'s penis!' while _____ screamed in
(baritone Goth crooner) _(from Growing Pains)_

retort, 'Well, _I_ licked hot sauce from between the toes of

_____ ... while _____
(vocalist from rival Goth band — the really bad one) _(overrated pomo architect)_

watched!' Who would have thought that _____
(a Canadian)

would be seen in public again with _____ after the
(1996's 'it' girl)

unearthing of the sordid home video of both of them

naked, in a hotel room with _____ , while _____
(brat packer) (corrupt mayor)

smoked crack sold to him by _____ .
('Oprah's Pick' author)

But there they are, laughing as _____ wanders,
(rumoured to be the next Bond)

sweaty, stoned and stripped down to his underwear,

cornering _____ , telling them, 'Don't you get
(cast member of Cheers)

it? Chuck Norris is a culture thief as brazen as Elvis or

Led Zeppelin!'

AN UNUSUALLY HAIRLESS GIBBON[9]

Initial post-mortem reports indicated that John Bonham was actually an unusually hairless gibbon. Reports also indicated that he did not die of alcohol poisoning, as previously believed, but from ingesting 'heroic' amounts of tungsten filament. In death, he purportedly gave off a warm frosted glow of approximately sixty watts.

MATT DAMON

Matt Damon remembers his cousins' basement in Burnaby, BC. Where each support pole was placed. One ski against a wall and one ski on the floor. His uncle's thick blue smoke swirling in the television light. This was where the old Matt Damon died, paying his cousins in quarters to recite lines from *Journey to the End of the Night*. The unfinished bathroom, half studs and half wood panelling, was his dressing room, a cardboard star attached to its door.

YO-YO DIETING AMONG FRENCH POST-STRUCTURALISTS: NEW PERSPECTIVES

Jacques Derrida didn't have to die. Or so claims a report released this week.

'Tenure is the number one cause of sedentary behaviour and therefore weight gain, which makes French critical theorists particularly vulnerable to medically unsound dieting,' says Dr. James Haul, principal author of the study. One need look no farther than the startling facts to agree. Derrida, once a svelte 180 pounds, was, at the time of his death last week, 304 lb. Julia Kristeva is now a hefty 270 lb. Paul Virilio — currently awaiting a triple bypass — weighs 354 lb. Fatty Roland Barthes died at 402 lb. while choking on a foie gras sandwich. All have admitted to attempting various fad diets, which Haul claims only exacerbates the problem.

'Jean Baudrillard can go on the Saltwater Diet and lose his wine-and-cheese paunch in several weeks, but statistics suggest he'll lapse and gain the weight back two-fold.'

Haul is, of course, referring to the incident that occurred during a televised lecture where the reclusive theorist came out onstage clad in a blousy muumuu which he subsequently ripped off to reveal a slim new physique while pumping his fists in the air, driving the

audience wild. Later in the same show, Baudrillard dragged out a Mr. Turtle pool full of beef scraps and lard, representing his 70 lb. weight loss, shouting, 'A representation ... of absence!'

The problem, Haul argues, is as much about age as it is ideology. 'Today's theorists take in a lot more pop culture than their predecessors did. The Frankfurt School averaged two hours of television a day. Sartre would watch only *Petticoat Junction*, but these academics are averaging four or five hours of *Law and Order* a day. That's got to have an effect on body image. They see Britney, they shop at the malls, and with the peer pressure to look good, it becomes a social thing. It's tragic, really.'

KEITH RICHARDS

In the east wing of the house, the supermodels were talking in low whispers to each other. Christy Turlington was crying and wringing her hands. Elle Macpherson was as pale as death. After about a quarter of an hour they crept upstairs. They knocked, but there was no reply. They called out. Everything was still. Finally, after vainly trying to force the door, they got on the roof and dropped down on to the balcony. The windows yielded easily — their bolts were old.

Hanging upon the wall was a grotesque portrait of their guitarist as they had last seen him, in all the rot of his decayed senility and ugliness. Lying on the floor was a dead man, in snakeskin boots, with a knife in his heart. He was youthful, angelic and placid of visage. It was not till they had examined the skull rings that they recognized who it was.

THE TEACHINGS OF DON KNOTTS:
A YANKEE WAY OF KNOWLEDGE[10]

I first encountered Don Knotts on the set for *The Apple Dumpling Gang Rides Again*. I was struck by his immense stillness, as if he were carved from stone. I would ask him questions and he would answer with the silence of his clear blue eyes.

'Where's craft services?'

'It is the nature of infinity, once we cross a certain threshold, to put a blueprint in front of us.'

'I'm a little worried about the wagon gag today.'

'One has to reduce to a minimum all that is unnecessary in one's life. The countless paths one traverses in one's life are all equal. Oppressors and oppressed meet at the end, and the only thing that prevails is that life was altogether too short for both.'

'Did you see the script for *The Shaggy D.A.*? It's some amazing shit.'

'All paths are the same: they lead nowhere. They are paths going through the bush, or into the bush. In my own life I could say I have traversed long long paths, but I am not anywhere.'

THE STRANGE MADNESS OF ROBERT URICH

It emerged from the hole in Robert Urich's garage floor, slimy, primordial, non-Euclidean — a thing of madness. Urich himself was blind, insane, dancing a naked savage dance as if the eldritch beast were commanding him with a serenade piped by idiot flute players. The dance grew in intensity as the beast's tentacles draped around poor naked Robert Urich, drawing the wretch into the diaphanous light emanating from that unholy fracture in time and space we had rashly and foolishly opened.

STYX

During a lugubrious, drawn-out version of 'Mr. Roboto,' vocalist Tommy Shaw, hoarse and tired, asks the audience, 'Ever get the feeling you've been cheated?' Bassist Glen Burtnik is on the nod, pulling at his bass strings as if they are snot. His arms are bloody with self-inflicted wounds. The fans have thrown bottles on stage in hopes that everyone's favourite human wreck will deliver. Drummer Chuck Panozzo keeps the monotonous beat going as his band dies around him, the music tantamount to a dub.

From five street urchins hanging around a sex shop to world-famous saviours of rock, from that first banned single, had only been a year.

MARGARET TRUDEAU[11]

She came to Studio 54.

And it said, 'Draw not nigh hither: pull thy panties from thy thighs, for the place whereon thou standest is holy ground.'

And she looked, and, behold, the mirror ball burned with fire, and the mirror ball was not consumed.

YOKO ONO

Yoko Ono, who married Aristotle Onassis, who married Jackie Kennedy, who married Fernando Lamas, who married Jennifer Love Hewitt, who married Michael Madsen, who married Kathy Acker, who married Lee Majors, who married Roxanne Pulitzer, who married Anthony Sabato Jr., who married Connie Sellecca, who married John Tesh, who married Dolly Parton, who married Martin Amis, who married Sofia Coppola, who married Larry Hagman, who married Steffi Graf, who married Andre Agassi, who married Mia Farrow, who married Dustin Hoffman, who married Rae Dawn Chong, who married C. Thomas Howell, who married Marilyn McCoo, who married Tommy Lee, who married Pamela Anderson, who married Michael Landon, who married Exene Cervenka, who married Viggo Mortensen, who married Traci Lords, who married Ted Nugent, who married Camille Paglia, who married Joe Pesci, who married Corazon Aquino, who married Emilio Estevez, who married Sheena Easton, who married Gary Coleman, who married Linda Evangelista, who married Bernardo Bertolucci, who married Tina Turner, who married Michael Turner, who married Tatum O'Neal, who married Maurice Gibb, who married Tori Amos, who married Chow Yun-Fat, who married Meg Tilly, who married The Rock, who married Vanessa Williams, who married Will Self, who married Linda Evans, who

married Yanni, who married Kathryn Bigelow, who married James Cameron, who married Melissa Gilbert, who married Elvis Costello, who married Maya Angelou, who married Tom Arnold, who married Kim Basinger, who married Beau Bridges, who married Angela Bassett, who married Sean Astin, who married Kate Capshaw, who married Jim Belushi, who married Brittany Murphy, who married Ken Kingsley, who married Paula Abdul, who married Bruce Willis, who married Lisa Kudrow, who married Greg Kinnear, who married Catherine Oxenberg, who married Yaphet Kotto, who married Ricki Lake, who married Micheal Keaton, who married Milla Jovovich, who married Luc Besson, who married Nancy Kerrigan, who married Jim Kelly, who married Angela Lansbury, who married Rick Schroder, who married Emmylou Harris, who married Donovan Leitch, who married Farrah Fawcett, who married Joe Montana, who married Lynn Crosbie, who married Jan-Michael Vincent, who married Jeanette Winterson, who married Stephen Stills, who married Minnie Sharp, who married Luke Perry.

JESSICA SIMPSON'S GRANT APPLICATION

In This Skin is a series of songs that will explore our ongoing relationship to and notions of fate and mortality. Accompanying the aural elements will be still and video images of stagings and performance pieces that when viewed as a whole will — because of my choice of forms — have the appearance of a melodramatic narrative but, upon closer inspection, will reveal abstraction spreading like an oil slick. Individual pieces, such as 'Forbidden Fruit,' constitute a sustained 'pollution' of hierarchical forms.

A grant will allow me to build upon my previous practice, such as 2001's *Irresistible*, and develop a new language of material skills with which to delineate loss and love.

EZRA POUND

Ezra Pound has been erroneously identified as the namesake of the 'pound key' found on most telephone touch pads. (This is, of course, conspiratorial gobbledygook best left to conjecture by the marijuana-addled sages of undergraduate dormitories.) But he was the inventor of the Pound Cake.

He refined the recipe of simple, easily obtained ingredients during his time in a tiger cage in Italy. Yet, because of Pound's lack of business acumen, we see the Pound Cake sitting stale and gummy on shelves around the world, with nary a dime from copyright or royalty in sight.

MICK JAGGER

Mick Jagger is shrinking to subatomic size. He is very portable. Little Mick enjoys our home immensely as he deals with his novel condition.

But what if Mick shrinks so small he sinks into the carpet and judges us by the dirt, the chip crumbs and the human skin cells that layer the carpet in a fine dust?

He will always be too big for that.

THE WORST DRESSED AT THE
GOLDEN GLOBES

Madonna has undergone countless transformations, but the abandoned-late-colonial-surveying-a-crumbling-empire look just doesn't suit her. The jodhpur-and-pith-helmet-sporting superstar's frizzed-and-braided tresses at the 1999 Golden Globes are more suited for French Indochina than the TV-and-film fête.

White can be clean and elegant, or it can wash you out, like it did Lara Flynn Boyle at the 2000 Golden Globes. She raved to *Portable Altamont* about her Sebra speed skating suit: 'It's Coolmax tech-fibre-based for optimum transport of heat and sweat. It's so classic, and it looks great on the skin.'

Will the real Gwen Stefani please stand up? Radar-absorbent epoxy was the new black at the 2001 Golden Globes, but combined with her vaguely flapperish dress (with every surface curved in order to deflect radio waves) it didn't seem to add up to anything other than its $20-billion price tag.

Rosanna Arquette. Where to begin? She prides herself on being casual, but showing up at the 2002 awards right after a lipoplasty surgery, still in the surgical gown with the cannula hanging out of her left butt cheek and her anesthesiologist in tow was simply wrong.

Sela Ward's thick red scarf, dirty gloves and brass bell — the traditional costume of the medieval leper — missed the mark at the 2003 Golden Globes. But don't tell her that: 'It's fun and festive and Valentinesy and red,' the former *Once and Again* star told *Portable Altamont*.

Blago Bung Blah! Is there anything worse than an obscure intellectual in-joke masquerading as fashion? In 2004, when country music first lady Faith Hill led a lobster on a leash down the red carpet while wearing an apron, it didn't scream 'I've read Nerval'; it screamed, 'I'm a dork who doesn't get laid.'

WHAT'S NICOLE RICHIE LOOKING FOR IN A MAN?

'I'm totally into a mean, lean omentum — the apron-like double fold of fatty membrane that hangs down in front of the intestines. You can't get that at a gym.

'Don't think I'm weird, but a small ulnar artery is *sooo* cute. But the retromandibular should be strong and pumping. That shows he's intense! And I've left otherwise great guys who've got a weak pancreas with a malfunctioning cystic duct.

'I'm not shallow, though. A lot of men don't have enough proximal convoluted tubules in their renal cortexes and I'm not going to hold that against them.'

THE EYES OF TAWNY KITAEN

Provoking the body's inherent reflexes, Kim Cattrall's approach in *Porky's* is relational, experiential and pheno-menological. This haunting performance animates the psychological residues of experience, lending form and voice to the inexpressible.

Conversely, *Bachelor Party* was produced in an environment of wartime volatility; this is reflected symbolically through-out its *mise en scène*. The film establishes an atmosphere saturated in paranoia and distrust. Tawny Kitaen reflects back the identity of those who look into her eyes.

Completely rejecting that gaze (and all external narrative) is *Fraternity Vacation* (1985), which was made without a camera. Director James Frawley collaged objects directly onto perforated tape the width of 35mm film, from which projectible prints were made. The resulting rapid burst of imagery has a highly controlled musical rhythm.

WHEN WE ARRESTED JAMES SPADER[12]

It was the saddest thing I'd seen. How he kept on thinking he was a cat and he wouldn't get out of that filthy litter box.

And then, in the back of the cruiser, meowing for his cat brothers to save him.

WINONA RYDER

Former *Full House* heartthrob John Stamos swears by the latest celebrity craze: working in textile sweatshops. 'I was pretty messed up until I signed on at Allied Fabrics and Export. Silently performing the same motion for twelve hours taught me focus and how to have goals. It's not just spiritual. The five-minute lunch means you concentrate on essential foods. I lost ten pounds in a month. And this isn't just recently dreamed-up fad stuff. Poor women have known and used this tradition for years.'

Some say that Stamos's ex-wife Rebecca Romijn left him because she couldn't dedicate herself to seven-day work-weeks and toxic fumes. Maybe that's why he's hooked up with fellow devotee Winona Ryder.

'We learn that all time must be "profitable" time,' says Ryder. 'We learn to obey only the "shop manager," and not only to obey him but also to allow "productivity" to be "audited." I fought against it till I had to serge 200 yards of chiffon by the end of a shift. I was about to crack until a pure white light came over me. Then I knew I would be okay. That's the lesson, that life is one shift at a time.'

Somewhere in Malibu, Singer machines sound a distant chorus.

MARY STUART MASTERSON

Mary Stuart Masterson holds the record for the longest spaghetti strand blown out of a nostril in a single blow. On December 16, 2003, Mary successfully achieved a record distance of 19 cm (7.5 in) on the set of *Guinness World Records: Primetime* in Los Angeles, California, USA.

CANDACE BUSHNELL

No one knows Candace like he knew Candace.

He knew her before she cut her hair, when she stumbled blindly around like Cousin Itt, thick locks surrounding her entire head.

She had never known colour until a child with hideous cranial facial problems explained colour to her by placing in her hands heated (red), chilled (blue) and then lukewarm (pink) rocks.

Once she got her hair cut she didn't need the dumb rocks anymore.

EIGHT FASCINATING FACTS
ABOUT CANADIAN AUTHORS

They're not originally from Canada. Paleontologists have evidence that Canadian authors originated on the Asian steppes in the Eocene epoch (40 to 50 million years ago), ranging through Asia, Europe and Africa. Today their range is limited to urban Canada.

They're mentioned in the Bible. Numbers 22:23 – 'And Balaam smote the Canadian Author.' From the earliest times, they've attracted interest and attention.

Cleopatra may have ridden one. According to the Canadian Literature InfoNet web page, 'Ancient Egyptians trained Canadian authors to pull carts. Teams of Canadian authors were sometimes used in Rome to pull chariots in races.'

A Canadian author can easily kill a man or a horse. Fierce fighters (and often volatile even when domesticated), their sideways or straightforward kicks with powerful legs and hard feet can be lethal.

To calm a Canadian author, put a sock on it. If it can kick, bite and peck, one might wonder how cranky it is when restrained. Texas A&M University's English Department's website notes, 'Darkness or limited light seems to quiet Canadian authors and make them easier

to handle. Pastured varieties (academic or elderly) may be approached safely at night with a flashlight.' For daylight handling, 'Hoods are sometimes used to restrain adult Canadian authors.' Handlers know that they seldom kick backward, so it's safer to approach from behind.

Canadian author hair helped in the making of your car and computer. Canadian author hair has recently found its way into high-tech applications, including the use of hair-covered rollers to remove static dust before painting automobiles in the assembly lines. There are also applications in the computer industry.

One Canadian author = three pairs of cowboy boots. The Alberta Agricultural Extension Service at the University of Calgary reports, 'Canadian author leather is a popular product for making boots, clothing and upholstery. An adult author will produce 14 square feet (1.30 sq. metres) of hide. One hide can make three pairs of boots.'

Canadian author meat is served in gourmet restaurants. The following sources can lead you to eateries that serve 'the other red meat.'

GLEN CAMPBELL

As surely as Judd Nelson films an erotic thriller in Toronto — cold, hateful, diseased Toronto — Charles Nelson Reilly crumbles a communion wafer in his fist, raises it to the sky and says, 'Just you and me now, sport.'

The military is studying James Earl Jones. He can express infra-sonic frequencies that can crack dams and pop rivets from ships. Tommy Lee Jones performs a rare form of yoga where a knotted pretzel passes through his body undigested and unbroken.

Neve Campbell digs holes late in the night so her sadness may tumble into them. Glen Campbell will once again spend the evening at the bar giving unrequested massages and telling perfect strangers, 'Y'all got your chakras fucked up somethin' fierce.'

SEEN! Fred Durst and Germaine Greer making love!

NOTICED! Since studies showed the anti-malarial drug quinine causes short-term sterility, stars — including a recent Oscar grabber — have been lining up for quinine smoothies and quinine bubble tea along Roh-day-oh Drive.

HEY, LONG-TIME VEGETARIAN DAVID DUCHOVNY! What are you doing drinking blood from an ox's jugular with the Masai?

SKI INSTRUCTORS EVERYWHERE, BEWARE! Claudine Longet is still alive!

LIFE'S RICH PATHOGENS! A certain talk show host has received so many Botox treatments that he is banned from all A&P and most Farmer Jack grocery stores for fear of contaminating the canned goods as he walks past them. Sounds like Maury Povich.

OUCH! Is there an arcane religious practice that the celebs won't endorse? Kevin Spacey recently participated in the Sioux ritual of the sun wherein he was suspended for hours on long rawhide strands hooked into his chest.

REVEALED! J. Robert Oppenheimer's two dozen plastic surgeries! The pacifist father of the nuclear age was tired of having sand kicked in his face by the new buff generation of playboy physicists. Good friend Jill St. John recommended her spackler to him, which resulted in a brow lift, dermabrasion, sclerotherapy, otoplasty, liposuction, blepharoplasty, hair transplantation, pectoral implants and what many considered to be an unnecessary nose job.

FROM SUNDANCE TO SUNBLOCK! One guy who's proud of his wrinkles, Robert Redford, is so proud of them he's working with Pixar on updating his image in all his previous movies to match his present age. You go, Great-Granddaddy Gatsby!

BURNING DOWN! A world as badly made as this one where violent rebellion is the only path.

NOTES

1 There were two bands named Pure: the more popular Vancouver Pure and the lesser-known Toronto Pure, who, I've been told, rocked in a mid-period Cult manner, which is to say not very well.

2 Danza continued on to describe his work as a Bataille scholar, focusing on his translations of recently discovered letters from the Bibliothèque Nationale. Dated from the final years of Bataille's life, the letters cast him in a revolutionary new light. All letters (unopened and returned) are addressed to Leslie Gore and contain verses such as:

> Gallic stubble will caress
> freshly shaven thighs
> were it not for fluids
> interrupting, awkward as
> a bellboy proffering a lily
> to a corpse.

> No tip for you.

3 People find this a strangely beautiful piece, bursting with eschatological imagery. The schism between real and fictional texts will, I hope, give the reader a sense of what the end times will really be like — namely, characters from *The Facts of Life* coming at us with knives and burning our cities.

4 For further evidence, consult Adrian Lyne's astonishing debut film, *Foxes* (1980). It features soft-focus photography and a moving score by Giorgio Moroder, and Jodie Foster plays the role of den mother to a group of runaway girls in Los Angeles, including — I shit you not — Cherie Currie of the Runaways, riding in a pickup truck, swigging a bottle of peach schnapps, her bleached and feathered hair blowing in the wind.

5 Darren Wershler-Henry is a former child star who can be seen in the films *River's Edge* and *Near Dark* and on reruns of the television show *21 Jump Street*.

6 My brothers and I finally came to the conclusion that Uncle Bill had not gotten drunk with Ozzy Osbourne on his trip to Toronto. As much as we laughed at the idea of Uncle Bill meeting the beheader of bats, I would, during the fourth grade, go to school and likewise claim not only to have attended the previous evening's Ted Nugent concert but to have actually hung out with the Nuge backstage. As with my reaction to Uncle Bill, I'm sure my classmates believed me for a second but then quickly surmised that I did in fact spend the evening in my underwear eating Cheez Doodles and watching *Dukes of Hazzard*.

7　Did Betty and Jakob ever tell you about when they went to that Autechre show five years ago? They took a shuttle bus to some warehouse in North York. The place was completely pitch black except for one red laser beam dancing across the ceiling. In the body-against-body darkness, a girl beside them had a drug freak-out and was whisked away by these black-clad security guards waving flashlights around like Jawas. If you're that girl reading this, Betty really liked your skirt and wished that circumstances were different so that she could have told you at the time.

8　Due to limited space, the original inventory of the contents of Shakur's bags was edited down to a more manageable size. Following is a further sampling:

> raw industrial diamonds
> Bob Barker's head
> lithium chunks
> hair curlers (though not on Bob Barker's
> head — he wanted you to know that)
> instant rice
> Michael Bolton's first 'rock' album (with
> 'Bolotin' typo)
> Cliff Burton's bloodstained Misfits shirt
> Andrei Tarkovsky's moustache
> wet coffee grounds
> a drum kit made from broomsticks and
> cardboard boxes
> a BB gun found in the garage

leopard-print bikini underwear

Regis Dubray

a box of 5¼ floppy discs with Autocad 1.0 on them

a gift certificate for Tunnel Bar-B-Q

a package of salami with tire marks, plucked
from the street by two hungry punks in 1991

a cassette bearing the final crazed rantings of
Klaus Meine, vocalist of Scorpions

keys to a 1986 Audi

a bottle of water from the hot tub of Robert
Evans, noted for its healing powers

a bad doll sculpture from the mid-nineties
made by an art student

one black Thinsulate glove

a copy of *We Want Some Too* by Hal Niedzviecki

a Boss distortion pedal with weak nine-volt
battery

a torn black velvet 'Head of the Class' poster

a bootleg of the non-stuttering version of
BTO's 'You Ain't Seen Nothing Yet'

a Leica filled with toothpaste

Rik Allen's missing arm

all of Suzanne Somers's books, discarded
from the Port Hope library

a self-published book of poetry by DRI
vocalist Kurt Brecht (grandson of Bertolt)

a videotape of Headbanger's Ball sent by a
cousin from the States

Darby Crash's rat-tail

a half-used bottle of NyQuil
a Franklin Mint 'Lives of Freud' plate featuring
 the young Freud dissecting the nervous
 systems of eels
a receipt for a $10 money order for a Pocket
 Canon that was never sent
a used piece of depilatory wax
a glued-back-together WAMBO coffee mug
an issue of *Rampike*
a 386 turned into a planter
a home defibrillator kit
a bag of hardened brown sugar
the lost master tapes from Manowar's
 comeback album
a love note to Ann Marie Goodfellow

The above passage should be inserted between 'Spear of Destiny' and 'chewed bread.'

9 I hated Led Zeppelin for years for probably the same reasons you do. Until one day some time ago, _____ sat me down and got me good and stoned and played 'Dazed and Confused.' The twenty-two-minute live version from *The Song Remains the Same.*

10 Surrealist playwright Fernando Arrabel once remarked, 'I have been called a genius — that's horrible, I only want to be a saint.' Can it be said that one man, Don Knotts, was indeed both saint and genius?

11 While Canada's prime ministers have historically been weedy, venal, old, bitter men, our first ladies have led liberated lifestyles more befitting the GTOs than dowdy mothers of the state:

PM'S SPOUSE	ROCK STAR	RUMOUR
Annie Thompson	John Philip Souza	Daguerrotyped coming out of a hotel without her bustle!
Olive Diefenbaker	Jerry Lee Lewis	He was too old for her
Maureen Clark	Chrissie Hynde	Shared vegetarian recipes
Geills Turner	Vince Neil	Video for 'Looks That Kill' filmed at 24 Sussex Drive
Mila Mulroney	Slash	G&R broke up when her eyes turned to Duff
Howard Eddy	Courtney Love	Notoriously attracted to intense blondes

PM'S SPOUSE	ROCK STAR	RUMOUR
Aline Chrétien	Richie Manic	Assisted in his disappearance (working at a Domo gas bar in Winnipeg)
Sheila Martin	Scott Weiland	Staged life-saving intervention with Melissa Auf der Mar and Tanya Donnelly

It should be noted that Canadian prime ministers are not without their influence and charms. Did you know that many of the giant monsters of Japanese cinema were modelled after our uniformly homely leaders? See if your guesses match the answers.

PM	MONSTER	SHARED ATTRIBUTES
John A. Macdonald	Ganime	Evil Crab
Alexander Mackenzie	Anguirus	Giant Turtle
John Caldwell Abbott	Rodan	Leathery Monster of the Sky
John Thompson	Matango	King of the Mushroom People

PM	MONSTER	SHARED ATTRIBUTES
Mackenzie Bowell	Manda	Snake God of the Undersea Kingdom
Charles Tupper	Minya	Doughy Son of Godzilla
Wilfrid Laurier	Gidorah	Three-Headed Monster
Arthur Meighen	Hedorah	Smog Monster
Louis St. Laurent	Megalon	Napalm-Breathing Monster of Seatopia
John Diefenbaker	Mecha Godzilla	Rubber-Covered Robot
Lester B. Pearson	Ebirah	Monster of the Deep
Pierre Trudeau	Ookondru	Mutant Condor
Joe Clark	Yog	Space Amoeba!
Brian Mulroney	Gaira	Fifty-Foot Missing Link
Kim Campbell	Kroiga	Flying Griffin
Jean Chrétien	Varan	Monster Dog Destroyer
Paul Martin	Moguera	War Machine with Laser Eyes

12 James Spader's famous court speech, 'Am I man dreaming
 he is a cat or a cat dreaming he is a man?' divided the world
 of philosophy and letters. Borges most eloquently summed
 up the quandary on *Entertainment Tonight*:

> We shall never know if James Spader saw an
> opulent kitty-condo, which he seemed to scratch,
> or an elegant tabby, which no doubt was he, but
> we do know that the image was subjective. There is
> no other reality, for idealism, than that of mental
> processes; adding an objective pussycat to the
> pussycat that is perceived seems a vain duplica-
> tion; adding a self to these processes seems no
> less exorbitant. The world, unfortunately, is real.
> He, unfortunately, is Spader.

13 The specialists of gossip will say that this book's politics are
 bad; the politicians among the left-wing illusionists will say
 that it is bad gossip. But when one is at once a gossip and a
 revolutionary, one may easily demonstrate that their
 general bitterness derives from the obvious fact that the
 book in question is the exact critique of the society that they
 do not know how to combat, and a first example of gossip
 that they do not know how to make.

ERRATA

Vos narro sol solis ego spiritus incendia

p. 8 Bryan Adams has never blown a Skinny Puppy in a Honeymoon Suite.

p. 9 I bear neither ill will nor special fascination for Pert, Russell Smith, or any other Procter and Gamble products. I just think they look really nice together in a paragraph.

p. 10 Ethan Hawke once said, during a lecture for the Modern Language Association, 'Yeah, I admit it, I learned more from *Zero Degree Fighter* than *Writing Degree Zero*.'

p. 11 Title should read 'The Red G-String.'

p. 12 Margaret Atwood denies threatening Suge Knight but is currently suing him over rights to her Death Row back catalogue.

p. 13 Emily's best friend while growing up told her, in all seriousness, that Houston was 'So obviously a lesbian' because of the way she tapped the microphone with her fingers.

p.14 Tony Danza, it should be remembered, was a founding member of the Living Theatre, and, as such, is always in search of 'an impossible stage.'

p. 15 Mrs. Garrett had a talk with Blair and everything is fine now.

p. 16 Add, 'Reprinted from *The Muppets Take Modernism*.'

p. 17 My grandparents had *The Waste Land*, my parents, *Howl*. The tome of my generation? Perhaps it's Michael Madsen's *46 Down: A Book of Dreams and Other Ramblings*. Perhaps.

p. 18 Charles Whitman has recently replaced Walt Whitman as America's most beloved poet.

p. 19 This poem was written in collaboration with Michael Madsen when we attended Naropa together.

p. 20 There is no word in Sanskrit for 'Supersize It' but there is one for the less poetic 'Biggie Up.'

p. 21 Philip Roth is indeed David Lee Roth's brother and can be heard singing backup vocals on much of *Eat 'Em and Smile*.

p. 22 Many doubt whether Darren Wershler-Henry, 'the man who killed the nineties,' will ever be released from prison.

p. 23 This was written for the three people (including The Author) on the planet who get excited (for all the wrong reasons) when Oliver Stone's *The Doors* is on television.

p. 24 Sean Penn still cries himself to sleep.

p. 25 *Portable Altamont* readers, this is your chance to vote for the worst vanity film project of all time by an overconfident rock star. Your choices are: Neil Young's *Human Highway*, Bob Dylan's *Renaldo and Clara*, Perry Farrell's *Gift* and Phil Collins's *Maldoror*.

p. 26 The number of days left till the release of *Chinese Democracy* is commensurate with the odds against *Portable Altamont* being nominated for a literary award.

p. 27 Being in love means never having to say 'Those who talk of revolution without making it real in their own lives talk with a corpse in their mouths.'

p. 28 As of May 2, 2005, there is not a single fan page for Mary Hart on the web.

p. 29 The biography of Jimmy Stewart tells a life of many parts: writer, actor, husband, father, founder of Project Sigma, heroin addict. In the late 1950s Stewart began his experimentations in drug culture. It was at this time that Stewart wrote *Jimmy Stewart and His Poems*, telling of his sexual misadventures and heroin highs. An excerpt reveals his mastery of Oedipal angst expressed through a totemic naïveté:

He never came to me when I would call
Unless I had a tennis ball
Or he felt like it
But mostly he didn't come at all

Oh, how I wish that wasn't so
I'll always love a dog named Beau

p. 30 Swayze and others recently founded the Malibu Zine Culture Expo. The top seller last year was Mira Sorvino's vulva-shaped homemade soap.

p. 31 When Will Self was assigned to cover Björk's last tour, he was amazed by the amount of time she spent on her laptop, forwarding personality quizzes to friends, exhorting them to 'Do this! It's so weird and dead-on!'

p. 32 Actually, I preferred Kangaroos.

p. 33 True ... and beautiful.

p. 34 High on Benzedrine, fingers popping to a Ken Nordine record, the Beats would play Mad Libs, sometimes for days, till the used-up pages collected like scrips on the floor.

p. 36 Infamous Satanist William Shatner lived with Jimmy Page at his Victorian mansion while Page composed music for Shatner's short experimental films. Page's drug

drug abuse turned the relationship sour, and Shatner would go on to claim authorship of 'Stairway to Heaven.'

p. 37 Actually, it was *Marat/Sade*.

p. 38 *Primetime* interview transcript, December 4, 2002:

> DIANE SAWYER (VOICE-OVER): Tonight, on a very special *Primetime*: Frederic Jameson, speaking out at last.

> DS (OFF CAMERA): In the mid-nineties, you said, 'I feel old.'

> FREDERIC JAMESON: Yeah, like I've been through a world, a lifetime of stuff.

> DS: I'm going to show you the picture.

> FJ: (*looking away*) Oh, yeah.

> DS: The vintage cars, the Coney dogs, it's because of drugs?

> DS: Is it alcohol? Is it marijuana? Is it cocaine? Is it pills? All?

> FJ: Yeah, I'll grant you, I partied.

DS: Fred dying. Crack rehab fails.

FJ: First of all, let's get one thing straight: crack is cheap. I make too much money to ever smoke crack.

DS: Okay, the Academy Awards.

FJ: Okay. I was fired from the gig. I didn't mind. I really didn't want to do it anyway. But I'm, I was past that, I'm past that, and it's over now.

p. 40 What's worse, supermodel humour or Keith Richards–based satire?

p. 41 As Don Knotts would say in a trance-like state, 'No corrections are correct.'

p. 42 Robert Urich never, ever opened a hole in time and space. Ever.

p. 43 Styx were never, ever cool. Ever. But they did open a hole in time and space.

p. 44 One cannot argue with history or holy words.

p. 45 While he never had a musical guest spot on the *Dukes of Hazzard*, Ted Nugent did have a guest appearance on

Miami Vice as a coke dealer named Rodney. I mark the airing of this episode as the date of the death of my childhood. After Ted Nugent was killed by Crockett I just couldn't believe in anything anymore. From then on, my adolescence was a depressing whirlwind of books by J. G. Ballard and albums by the Fall. I still, however, have a tattoo on my back that reads 'You Speak Sunshine, I Breathe Fire' in Latin.

p. 47 My goal with this book was that, as time progresses, empires would fall, formats would change and every single reference would, slowly and incrementally, produce a chorus of 'Who?'s. Jessica Simpson has, unfortunately, outwitted me with the strength of her career and robbed this book of its planned escape from history.

p. 48 Add 'Reprinted from *Keg Party and Cadence: The 1980s Sex Farce Reconsidered.*'

p. 49 Mick Jagger is now 1/100,000 the size of the period at the end of this sentence.

p. 50 The assumed supremacy of military technology should never be accepted. Consider NATO's AGM-88 HARM anti-radiation missile in Kosovo. Dozens of such missiles, each priced at over $1.2 million, were 'distracted' when civilians strategically left microwave ovens on in unpopulated areas. The ovens registered as 'tanks' and saved hundreds of lives.

p. 52 Add 'gastro-intestinal.jpg' to this page.

p. 53 Sadly true.

p. 54 James Spader knows he really is not a cat. Even if he acts like he doesn't know. Just squirt him with water. He hates that.

p. 55 In toiling to make designer clothing in sweatshops, then wearing those same clothes to the Golden Globes, celebs are actually living a Marxist dream world of unalienated labour. Crazy, huh?

p. 56 British artist Tracey Emin recently trumped Mary Stuart Masterson's record.

p. 57 I have no idea who Candace Bushnell is. And, I suspect (depending on what year you are reading this), neither do you.

p. 58 The real irony is the success Canadian authors have with writing multi-generational stories of conflict, incest and memory set on Canadian author farms.

p. 60 Glen Campbell is the chameleon of country music. Who else would be savvy enough to take their collection of mug shots and put them on gallery walls? The move has been heralded as the best development in conceptual photography in years. Over the breadth of his new

career, his work has grown markedly more aggressive in tone and more overt in its message. Witness the short, thrillingly malevolent titles: 'Drunk #1,' 'Drunker #8,' 'Untitled (High)' and the sublime 'Community Service.'

p.62 For his HUAC trial, Oppenheimer spruced up with an abdominoplasty, rhytidectomy and (a gift from his wife) a rarely performed septoplasty.

INDEX

ACKNOWLEDGEMENTS

District Attorney EMILY SCHULTZ believed that *Portable Altamont* had been the work of CIA personnel, anti-Castro Cuban exiles and ultra left-wing activists. 'My staff and I solved the case weeks ago,' Schultz announced as early as February 2002.

Schultz theorized that DARREN WERSHLER-HENRY's image as a loner and a leftist was merely a front, and that he had been set up to take the fall in a publication plot.

ALANA WILCOX (*above right, with Bay of Pigs veteran* BILL KENNEDY) was a highly eccentric pilot and scholar who drove from New Orleans to Dallas the night of publication, on 'vacation' with two friends – JASON MCBRIDE and CHRISTINA PALASSIO. Though the trip was thoroughly investigated by the New Orleans English Department, the Houston Police, the FBI and even the Texas Rangers, Schultz was convinced it had something to do with *Portable Altamont*.

Star witnesses PAUL DIFILIPPO, LYNN CROSBIE and IAN SVENONIUS claimed to overhear all major details of publication.

JEREMY RIGSBY was the dress manufacturer whose amateur Super 8 film is the only known footage of the making of *Portable Altamont*.

CARL WILSON was the jive-talking attorney who told the Warren Commission that he'd been asked by one 'SHEILA HETI' to represent Wershler-Henry in Dallas.

DAWN LEWIS, ELAINE GAITO and EMELIE CHHANGUR were ordered by Schultz not to reveal that Brian Joseph Davis had been unable to complete a polygraph test. PHILIP MONK was believed to be the elusive 'Clay Bertrand.'

Former FBI agents KRIS ROTHSTEIN, DAMIAN ROGERS, TERENCE DICK, ALISSA FIRTH-EAGLAND and MARC NGUI also have been suggested as having roles.

ABOUT THE AUTHOR

For several years artist Brian Joseph Davis has created deceptive films, writings and projects. He was called a 'genius' by Alex Ross of *The New Yorker* for turning the writings of philosopher Theodor Adorno into a punk rock seven-inch. *Frieze* magazine said of the same project, 'serious hilarity ... a joyous and thoughtful thing.'

Davis recently held auditions for the US Presidency on the streets and has developed a role-playing game set in the art world. This is his first book.

Typeset in Mrs. Eaves
Printed and bound at the Coach House
on bpNichol Lane, 2005

Cover image and half-title image by Brian Joseph Davis
Edited and designed by Darren Wershler-Henry

Coach House Books
401 Huron Street on bpNichol Lane
Toronto, Ontario
M5S 2G5
416 979 2217 · 1 800 367 6360
mail@chbooks.com
www.chbooks.com